ADVICE
FROM MY
80-YEAR-OLD
SELF

ADVICE
FROM MY
80-YEAR-OLD
SELF

Real Words of Wisdom
from People Ages 7 to 88

By Susan O'Malley

Afterword by Christina Amini

CHRONICLE BOOKS
SAN FRANCISCO

Library of Congress Cataloging-in-Publication Data available.

ISBN: 978-1-4521-3993-7

Manufactured in China.

Design by Brooke Johnson
Typeset in Galaxie Polaris

10 9 8 7 6 5 4 3 2 1

Chronicle Books LLC
680 Second Street
San Francisco, CA 94107
www.chroniclebooks.com

To Tim,
Today, until we're 80, and then some.

Introduction

What advice would your 80-year-old self give you?

Imagine you had the opportunity to time travel and meet yourself at 80, to sit down and have a cup of tea with your 80-year-old self. You look into her eyes, which are really your older, wiser eyes. It's a strange experience because this person feels so familiar but is also very different: she's older and has seen and experienced things that you don't yet know. Finally, after sitting with her for some time, you muster the courage to ask her for advice. You take a deep breath and wait for her to respond. What does she tell you?

For *Advice from My 80-Year-Old Self*, I asked this question to ordinary people of all ages whom I met at farmers' markets, senior centers, and public spaces near where I live in the San Francisco Bay Area. No matter how many times I've asked it, I am always surprised by how people respond. For the most part, it takes time for people to find their 80-year-old voice. She's always there though, her wisdom just waiting to be summoned and heard. She is likely a kinder, more courageous, and some-times even more practical version of you. Maybe she tells you that everything will be OK or reminds you to save money for down the road. Her words are comforting, reminding you what's important in life. She sees the big picture and is brave. She is kind to you in a way you may rarely be to yourself—which is ironic because, of course, she *is* yourself. The words and excerpts from over one hundred such interviews comprise this book.

It's easy to forget how wise we can be. We resist our internal wisdom due to any number of reasons, such as fear, fatigue, or inconvenience. We race through our hyperactive lives, so busy with the details of day-to-day living that we end up feeling disconnected from ourselves and each other. But what's great about the 80-year-old self is that no matter how frantic we get, she is always readily available to us. She is present within each of us, reminding us we can be the best version of ourselves, not through some colossal effort at personal reinvention, but simply by slowing down. We just have to take a moment to pay attention and listen.

I started this project because I needed to listen to my 80-year-old self. At the time, I spent sleep-less nights wondering, *Should I leave my grown-up job with a paycheck and benefits to pursue my artistic passions?* This ongoing dream felt terribly irresponsible, scary, and uncharted. But with the rapid illness of my mom, who was only in her 60s at the time, life suddenly felt too short *not* to take a risk. How would I feel at 80 if I did, or did not, make this choice? Before I had the courage to truly take the leap though, I turned to the words of strangers to help me navigate my way.

In every conversation I've had for this project, I'm reminded how we all are looking for similar things in our lives: meaning, security, happiness, community, and love. *Your heart has reasons your head does not know; love is everywhere, look for it; do the things that matter to your heart.* The words of others often express what I'm thinking but haven't yet found words for. It's these moments of hearing what I recognize as truths in the voices of others that make me feel alive, connected, and understood. Yes, we are all in this together.

It's my hope that as you read through the advice and voices of the generous people I interviewed, you will find words that speak to your own inner truth, the wisdom contained within you that is expansive and generous. And if you don't find exactly what you need, just take a deep breath and ask your own 80-year-old self.

Bailey, 19 years old

YOU'RE OK

Catherine, 45 years old

IT WILL BE BETTER THAN YOU IMAGINED

YOU DON'T NEED TO KNOW WHERE YOU'RE GOING

Sebastian, 37 years old

NOTHING WILL BE WHAT YOU EXPECTED

Karen, 51 years old

EVERY THING MATTERS

David, 42 years old

opposite

Alicia, 37 years old

THIS
IS
YOUR
LIFE
LOVE IT

Pascal, 8 years old

LISTEN
TO YOUR MOM

BE FRIENDLY
TO PEOPLE

DON'T PULL
PEOPLE'S HAIR

Emilia, 12 years old

TRY
NEW THINGS
IT'S
OK
TO MAKE MISTAKES

Carol, 44 years old

MAKE THE WORLD A BETTER PLACE

Julian, 56 years old

IT IS POSSIBLE

KEEP TRYING DON'T GIVE UP

ONE DAY AT A TIME

Dionte, 21 years old

opposite

Matt, 8 years old

MAKE IT UP

AS YOU GO

Richard, 55 years old

opposite

Liz, 25 years old

COLOR OUTSIDE THE LINES

Doug, 44 years old

ENJOY YOUR HAIR WHILE YOU HAVE IT

MAKE MORE FRIENDS

Bonnie, 49 years old

DON'T EVER LIE

Barbara, 82 years old

Susan, 49 years old

LET
YOUR
FEELINGS
BE KNOWN

Cynthia, 63 years old

SLOW DOWN AND SMELL THE ROSES

SCHOOL
FIRST
PARTY
ON THE
WEEKENDS

Bailey, 19 years old

opposite

Larry, 88 years old

TRY
AGAIN
AND
AGAIN
AND
AGAIN

BE
YOU

YOU
ALREADY
KNOW
WHAT YOU
NEED

Bella, 21 years old

opposite
Rachel, 24 years old

Kelly, 25 years old

LESS INTERNET

MORE LOVE

EAT WELL EXERCISE MAKE HOBBIES AND FRIENDS

Caroline, 71 years old

READ MORE CHAPTER BOOKS

Jennifer, 7 years old

LAY OFF THE CIGARS START SWIMMING TRY SOMETHING NEW

Dan, 39 years old

PRACTICE COMPASSION

Sarah, 50 years old

opposite

Larry, 88 years old

APPRECIATE YOUR BODY

ESPECIALLY WHEN IT'S WORKING

Danielle, 21 years old

FORGIVE YOUR SELF

Ken, 59 years old

SAVE YOUR MONEY YOU'LL NEED IT

IT
GETS
EASIER

Rachel, 24 years old

BE THE PERSON YOU WANT TO BE

James, 35 years old

STUDY MORE

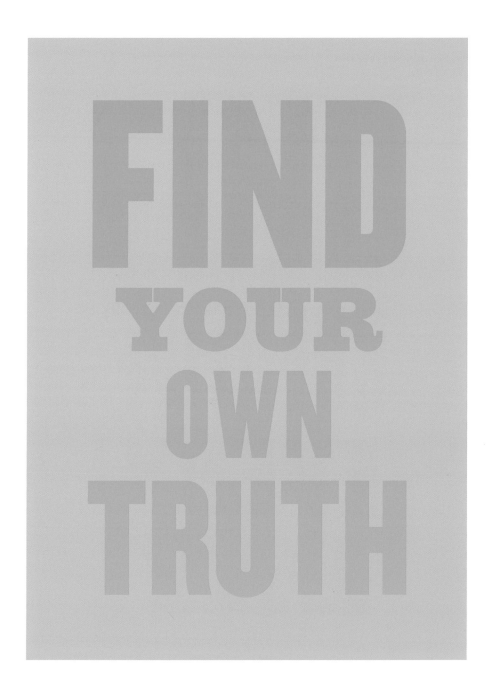

Heather, 24 years old

opposite
Greg, 14 years old

DO SOMETHING CREATIVE EVERY DAY

Susan, 49 years old

opposite
Kelly, 25 years old

GET OUT AND DO THINGS

Sylvia, 25 years old

IT'S OK

TO HAVE SUGAR IN YOUR TEA

Ed, 54 years old

DEAL WITH IT

BE
YOURSELF
AND
DO YOUR
HOMEWORK

Camille, 18 years old

YOUR LIFE IS PRECIOUS

Lars, 44 years old

opposite

Elaine, 71 years old

THIS
IS
A GOOD MOMENT
DON'T FORGET
THIS
MOMENT

LOOK TO OTHERS FOR HELP AND TO HELP

Josie, 72 years old

opposite
Abdul, 73 years old

LIVE EACH DAY AS IF IT'S YOUR LAST

Jessie, 50 years old

YOU
HAVE HAD A LONG WONDERFUL LIFE
GOOD
JOB

Laurie, 24 years old

YOU ARE SMARTER AND STRONGER THAN YOU REALIZE

Jose, 16 years old

PAY
ATTENTION
TO THE
GOOD

REJECT THE PAINT BY NUMBERS

Wendy, 51 years old

DO MORE OF WHAT YOU LOVE

Michael, 36 years old

Josh, 34 years old

FRIENDS BEFORE SCREEN TIME

STAY
IN TOUCH WITH
FRIENDS

BE NICER TO YOURSELF

Kristine, 35 years old

opposite

Joan, 85 years old

GO FOR IT

Jose, 35 years old

IT'S NOT A DUMB IDEA

Caroline, 71 years old

DON'T WORRY ABOUT WHAT OTHER PEOPLE THINK OF YOU

Chrystal, 14 years old

opposite
Sarah, 50 years old

YOU CAN'T CHANGE ANYONE EXCEPT YOURSELF

Caroline, 71 years old

DO
THINGS
THAT MATTER
TO
YOUR HEART

THE HARDER ROAD IS THE ONE THAT MAKES YOU YOU

Sal, 45 years old

Firoenza, 38 years old

NOTHING IS EASY NOTHING IS FREE

DO
THE
RIGHT
THING

YOU'LL GET THROUGH IT

Hope, 22 years old

opposite
Polly, 39 years old

Lauren, 23 years old

YOU MADE THE RIGHT CHOICES YOU MADE THE RIGHT MISTAKES

Pia, 31 years old

KEEP MOVING KEEP PLAYING KEEP DREAMING

Cynthia, 27 years old

IT
GETS
MORE
FUN

YOUR HEART HAS REASONS YOUR HEAD DOES NOT KNOW

Rachel, 24 years old

DON'T BE AFRAID

Alison, 29 years old

Jerome, 54 years old

I
TOLD
YOU
SO

Mike, 68 years old

IT WAS A GOOD CALL TO BUY THE RV

LOVE
IS ABUNDANT
MONEY?
NOW, THAT'S
A PROBLEM

Rafael, 61 years old

opposite
Margaret, 77 years old

BE BAD AT SOMETHING

PERFECTION IS OVERRATED

Lea, 62 years old

ART BEFORE DISHES

TRICK YOUR BRAIN AND SMILE

Lupita, 65 years old

LIFE
IS GOOD
ENJOY
EVERY BIT OF IT
NOW

Marcy, 82 years old

YOU CAN NEVER CATCH UP ON HAVING FUN

Linda, 65 years old

BE HERE NOW

TRAVEL
BEFORE
THE KNEES
GIVE OUT

Ben, 55 years old

LIFE IS SHORT MAKE IT GOOD

FIND THE FOUNTAIN OF YOUTH AND SOAK IN IT

Elaine, 71 years old

opposite

Hector, 26 years old

Cynthia, 49 years old

YOU DID YOUR BEST

Jon Jon, 35 years old

SIT BACK AND ENJOY THE RIDE

Kit, 83 years old

LOVE

IS EVERYWHERE
LOOK FOR IT

Afterword

Susan O'Malley: More Beautiful Than You Could Ever Imagine

by Christina Amini

It is a heartbreaking honor to write an afterword for this book. Susan O'Malley, my best friend and creative collaborator, died unexpectedly and far too soon, shortly before this book was published. She was 38 years old, in the last week of her pregnancy with twin girls Lucy and Reyna, who also did not survive. Their deaths are a devastating loss for her dear husband, her large and loving family, her friends, the art community, and her fans everywhere. While grieving, her community has found comfort and grace through Susan's artwork, which radiates her fierce and generous spirit.

Nearly twenty years ago, Susan and I met while living in the hippie co-ops at Stanford University (think vegan cooking and co-ed bathrooms). After college, we lived together in a series of apartments in Brooklyn, and within a 90-minute radius of each other in the Bay Area thereafter. We were friends as well as artistic collaborators, and Susan was ideal at both. She had a keen filter for separating what was important from what wasn't, and for finding humor and joy in life's weirdest moments.

We formed our Pep Talk Squad, an interactive art project, in 2004, when Susan started graduate school at California College of the Arts. We approached people with a question: "Is there anything that you need pep or encouragement on?" We wore matching red athletic jackets (as professional pep talkers do). We carried a portable typewriter. We listened attentively. One of us would ask questions while the other would sit at the typewriter, clickety-clacking out a message

for the stranger-now-confidant to keep. At the end of the Official Pep Talk, we would raise our hands in a cheer for the recipient: "Yay [Your Name Here]!"

We gave Pep Talks in galleries, at parks, in schools, at supermarkets. Strangers shared their vulnerabilities with us; we gave them our full attention and energy, even if just for fifteen minutes. In the process, we created unexpected and meaningful exchanges.

A social practice artist, Susan used simple and recognizable tools of engagement—a pep talk, a debate, a vending machine—to invite participants into the experience. Her artwork was not so much a finished product as a shared moment. Smart, empathic, and often silly, Susan asked for advice from strangers, wrapped inspirational posters on subway pillars, sold buttons with the names of every person she knew from a vending machine, staged a debate between MFA programs, and appointed herself as an artist-in-residence in a suburb of San Jose. All with her big infectious laugh, wholehearted enthusiasm, whip-smart sensibilities, and daring openness.

Susan's inspirational posters, with their bold color and direct text, have a pure heartfelt optimism in them. Drawn from pep talks, interviews with strangers, and her conversations with friends, she pulled the right text at the right time with the right colors to make you feel something new. Susan was an advocate of the great power of human connection and an expert at distilling life into its fundamental element: love. She had the singular

ability to find the essential truths and share them. They seem to be speaking to us all the time, and especially now: Listen to Your Heart. Allow Time to Breathe. We Are All in This Together.

Susan's bright light shone even in dark times. When her mother Guadalupe Reyna O'Malley was diagnosed with a rapidly degenerating disease, it recast the importance of mantras and positivity. Susan created some of her proudest work in collaboration with her mother by asking her to write messages before she lost the ability to steady the pen in her hands. "I love you baby." "Trick your brain and smile." Susan channeled the grace and goodness of her mother, and in the process provided us with a visible record of love.

Just before Susan died, she completed the *Advice from My 80-Year-Old Self* project, which resulted in this book, two temporary murals, and an art exhibit that spread her vision, warmth, and wisdom. Susan asks us to pay attention to the moments in our everydays. She reminds us to listen to our biggest and best selves, and to each other. Eighty years would not have been enough time with her. But Susan has given us the greatest and most profound gift—the reminder to cherish the present moment and each other in it. I keep hearing the words of one of Susan's pieces. "You are here," she said, "awake and alive."

A portion of the proceeds from the sale of this book will be donated to the Susan O'Malley Memorial Fund for the Arts.

Learn more about Susan O'Malley's life and art at:
www.susanomalley.org
www.advicefrommyeightyyearoldself.com
www.morebeautifulthanyoucouldeverimagine.com
#susanomalley

Christina Amini is a writer, art collaborator, and editor of books and gift products in the San Francisco Bay Area. As the Senior Creative Maximizer Associate on the Susan O'Malley Research Team (S.O.R.T.), Amini cofounded the Pep Talk Squad with O'Malley and worked with her on other important life research.

Acknowledgments

This project was made possible by the generous support of the Palo Alto Art Center and the Print Public Residency at Kala Art Institute. These wonderful arts organizations provided me the opportunity to ask questions and begin making the works that comprise this book. For this, I am truly grateful.

I am especially thankful to my ever-supportive editor Bridget Watson Payne, who had the brilliant vision to develop this project into a book format. Thank you for believing in it, making it happen, and making the process a pleasure.

Of course none of this would have been possible without the willingness and generosity of the people I interviewed in public spaces around the Bay Area. Thank you for inspiring me with your honesty, vulnerability, and openness.